MW00630015

KENZO

First published in the United States of America in 1999
by UNIVERSE PUBLISHING
A Division of Rizzoli International Publications, Inc.
300 Park Avenue South
New York, NY 10010

and

THE VENDOME PRESS

Copyright © 1999 by Éditions Assouline, Paris
Translated from the French by Elizabeth Currie

Front cover photograph: Spring-Summer collection, 1983.
© Hans Feurer
Back cover photograph: Spring-Summer collection, 1983.
© Hans Feurer

All rights reserved. No part of this publication may be reproduced,
stored in a retrieval system, or transmitted in any form or by any means,
electronic, mechanical, photocopying, recording, or otherwise, without
prior consent of the publishers.

ISBN: 0-7893-0382-5

Printed and bound in Italy

Library of Congress Catalog Card Number: 99-71286

99 00 01 02 / 10 9 8 7 6 5 4 3 2 1

UNIVERSE OF FASHION

KENZO

By Ginette Sainderichin

UNIVERSE / VENDOME

At the mountain's foot
in my dream of a spring night
flowers were scattered.
Kino Tsurayuki (late 10th century)

ime opens doors for those who know how to wait. The trajectory of Kenzo's whole career is summed up in this one short phrase. And doubtless his philosophy is too. And certainly his fashion. A life does not reveal itself; it narrates itself. At the heart of it, there is time: present time, time passing, the feel of the times; the interlinking of the seasons; the bursting forth of fashion.

Once upon a time, in the Hyogo prefecture of Japan, there was a small village, situated in the shadow of a great castle: the castle of Himeji, the oldest and best preserved of all Japanese strongholds. It was here, right next to Himeji, that Kenzo was born. He lived in the *machiai* (tea house) run by his father, an elderly functionary—"A large, taciturn, upright and rather rigid man."

Kenzo grew up to the rhythm of the smiles and voices of the singing geishas who were always present in the tea houses. He was the fifth of seven children: "My mother was active, attentive and courageous." First steps, first memories: music and songs all day long; the shimmering of colors and flowers when the merchants selling kimono fabrics passed by every season; the unchanging arabesques of the roofs of the castle of Himeji, at times rising up from the abundant greenery, at others surrounded by the cherry trees weighed down with blossom—just like a scene from a Japanese print.

Primary school, high school, untroubled studies. Kenzo played little with his classmates. He preferred the calm of his home, reading magazines such as *Sun* and *Himawari* (Sunflower), which he bought for his older sister. In the traditional way, she attended classes at a sewing school. Kenzo endlessly studied fashion photographs; he experimented with the patterns that accompanied the magazines; he made dolls and dressed them for his sisters. "This is how I edged my way into fashion and how, in my dreams, I sewed dresses for the round-eyed daughters of the far-off West."

He was dying with envy to enroll, like his sister, in a dressmaking school, but his father was opposed to the idea. In any case, boys were not admitted. He waited, he searched . . . and he found. In a train, over another passenger's shoulder, he read that the largest and most prestigious Japanese school of fashion, the Bunka Gakuen in Tokyo, had begun to accept boys. This was the first call of destiny, to which Kenzo responded immediately: he could no longer wait; he had to leave.

In order to pay for the trip, he worked part-time for a tofu seller. He became a sign painter, poorly paid but given board and lodging while staying in Tokyo. To pass the entrance examination, he took a correspon-

dence course and evening classes in an institute of fashion design. Six months later, he was accepted.

A new life began and childhood and adolescence came to an end. The death of his father seemed to prove this. The lights of the tea house were extinguished.

t hree years of studies, three years of emulation, competition, rivalries and friendships. Subsequently, Kenzo won an important prize in the competition for the best model on the theme "Wool in Summer" and he appeared in a number of reviews in various magazines, in particular *So-En*. Finally, he found his first employment: with Mikura, a designer of ready-to-wear, and later with Sanai, a specialist in fashion for the young where Kenzo created more than forty designs a month!

He began to gain important experience; the environment was sympathetic, the life agreeable: Kenzo was happy. He felt deeply that there was no need to rush anything. "Those who know how to wait. . . ." When one door closes, another opens. The building he lived in was going to be demolished for the Winter Olympics, and he was offered three hundred and fifty thousand yen in compensation for leaving. With this windfall, he bought a crossing to Europe, to take a tour of the capital cities. He embarked at Yokohama on the *Cambodia*.

He would always remember a month and a half of sea and stop-overs, of new horizons, and of discoveries: Hong Kong, Saigon, Singapore, Colombo, Djibouti, Alexandria. Sun, exoticism, landscapes, perfumes—skin-deep impressions, a string of wonders. This harvest of images and emotions became the key element of his collections, the essence of his shows. It also became the credo of his creativity: "The world is beautiful."

"A tree is green. All the trees are green. We have seen so many green trees that we have forgotten that there are also pink trees. But if all the

trees were pink, I would have shown you a green tree. The world is beautiful. Kenzo."

On January 1, 1965, the *Cambodia* arrived in Marseilles. It was winter. Marseilles was grey and cold. Paris would be sinister. Happily, like a perfect Japanese tourist, armed with his Nikon and faithful to the itinerary recommended by the travel agency, Kenzo visited Milan, Venice, Rome, Florence, Munich, Madrid, and London. But he had only one desire: to live in Paris, the capital of fashion.

In reality, Kenzo began what was to be an interminable apprenticeship. He did not speak French; he had no work, and almost no money. So he remained silent, he listened, he watched. It was the best way to learn: Paris is an open book.

Every day, he walked through the city. He observed the streets, he studied the shop windows, he contemplated the women. He went up the Champs-Élysées and stopped at Le Drugstore at the Étoile. A perfect observer, he could see everything without being seen: the youth fashions and the middle-class children of the 16th arrondissement, "All dressed in Shetland jumpers and navy macs, like English schoolchildren; lots of kilts, bags in the style of Chanel or Hermès, pearl necklaces, Italian shoes."

*g*radually, he made friends, and even dared to approach strangers. He showed his first designs to Louis Féraud, to *Elle* and *Jardin des Modes*, to the fashion desk at Printemps, to the Galeries Lafayette. He was taken on at Pisanti: "Drawings, materials, gradations—I learned a lot." He joined Relations Textiles (an advisory committee on marketing and style), where he specialized in knitting techniques. There he found some compatriots, notably Atsuko Kondo, a contemporary from the Bunka College, and a life-long friend. Together with her and another Atsuko (Atsuko Ansai, who worked with Mafia, a

style and promotions agency), Kenzo gave life and form to his dream. Happily, they joined together to paint the interior of the premises which Kenzo had somehow succeeded in hunting down. And so, in the Galerie Vivienne, there opened, with the ambiance of a tropical forest inspired by Douanier Rousseau, one of the most charming boutiques known to Paris: Jungle Jap. And thus the whirl of fashion began in a waltz of colors and with an air of celebration.

Kenzo's first show took place on April 14, 1970, in his boutique at the heart of the Grands Boulevards, far removed from the official salons and far, too, from the gilded salons of haute couture. In quick succession, he brought out five collections in one year: brilliant! Gradually, and with the first photos appearing in magazines (in particular, the front cover of *Elle*, word of Kenzo's designs began to circulate and grow louder. For the show that rounded off that first year, crowds thronged the great hall of the Galerie des Champs, on the Champs Élysées. Buyers and journalists from all over the world jostled around the podium. They laughed at the new inventions (the "rabbits' ears" hung on shoes), they applauded the mixtures of color, were amazed by Kenzo's audacity, and were surprised at being surprised. Because his fashion rang true, it exactly suited the expectations and desires of the new generation—the generation of the "events" of May 1968.

Through a sense of discretion and respect for the country that had welcomed him, Kenzo had not taken part in the demonstrations. He had kept back, but he had listened: the shock wave had not spared him. By instinct, he sensed that the time had come, for him as well, to call into question the lessons that he had so diligently learned at school, to open up his mind and find himself again. He returned to Japan for a brief visit and scrutinized his country with a new eye. He evaluated the changes and

rediscovered the wisdom of his culture. He contemplated the kimonos of his childhood and found them beautiful. A simple and refined beauty. Then came the final revelation: the western cut of garments, so sophisticated and attentive to the form of the body, suddenly appeared to him restricting. Restricting, like his past docility.

He returned to Paris with the bold intention of affirming his difference. He was going to show what he was, what he loved, what he could do. He eliminated the darts and zip fasteners that had constrained him. On a sinuous and close-fitting cut he superimposed a straight, clean, square cut—that of the kimono. He created the sensation of volume and gave space to the body. It was the first step towards freedom.

This notion of liberty was immediately apparent in the cheerfulness and lightness of the collections. The cheerfulness was first to be found in color. With Kenzo, color exploded; but not in a random way. He proceeded without aggression and at the same time without restrictions. He discovered new harmonies and played with different combinations. His designs created new associations and juxtapositions, broke up rhythms to re-create even better ones.

f or years, Kenzo was copied, imitated for his creativity, drawn on for inspiration. It did not matter: he had been the first to conduct the symphony of colors with such delicacy and mastery. Freedom blossomed with the flowers. All of Kenzo's collections are strewn with flowers—the best way of expressing one's love of life and the joy of being in France when one is not talkative by nature and has little grasp of the language. It was also the best way of demonstrating his origins, of asserting them without aggression. The cult of flowers, the tradition of flower arrangement, were part of his deep-rooted heritage. When it came to him in the form of inspiration, he tried to step back from it, just as he distanced

himself in his personal life from those around him, whom he met with a disarming smile and an unflagging kindness. This, then, was his subject matter. The form still needs to be explained. His first garments—short and voluminous, in pastel percale, Pompadour prints, or other subtly chosen cotton fabrics—appeared to be so light and fresh that the press called them flower-dresses.

after this, should we be at all surprised that Kenzo painted an enormous rose on the walls of his new boutique when he was forced to abandon the Galerie Vivienne and move into the Passage Choiseul? "It is inspired by a painting by Magritte. I simply replaced his apple with my rose." Gaiety, freshness, poetry, these words could be found again and again in the comments of the fashion press. But the word he himself preferred, which was engraved on his heart, was "liberty." Liberty to create, to assert oneself, to exist. Kenzo was not a revolutionary, still less an anarchist; his liberty was joyful. He laughed at the naivety and insouciance with which he had overturned habits and attitudes in the world of fashion, without even trying. There was nothing outwardly subversive in the first models he presented, a series of colored variations on a theme: the kimono. Yet, at the same time, he modified the rules. Brutally, he dispensed with the slender silhouette, the fitted sleeves, the straight shoulders of the sixties. It was a revolution in chiffon, because the form of the kimono not only freed the arm-holes, but also changed the whole line of the garment. Just like any liberation, this one was accompanied by imitations and variations. "I believe that this new proposition of mine formed the basis of the 'Big Look' which has been so successful."

Throughout the seventies, his creations were spot-on. They had the piquancy of adolescence, a spirit of happiness, and the sweetness of a spring day. It would be a shame not to pick them, in a dream, like wild

cherries. For is not Japan the land of cherry trees? Pick them without regret. In the little history of fashion according to Kenzo, there is no place for wistful nostalgia. Instead, we discover avant-garde ideas, true intuition and long-term vision—all portents which ought not to be forgotten.

In the forefront, obviously, came the kimono with its variants. And already he was creating unexpected combinations of colors, of materials, of designs, graphics, print applications, flowers, and stripes on a unified base. Patchwork led the way, with colors piled one upon another.

grey in winter, navy blue in spring, monocolor chic, lace for the evening—what had become of them? Where were the fashions of yesteryear? Kenzo had done away with the ritual of the seasons and the rules of elegance; he had appropriated the impertinence of youth and ignored normal conventions. He invented and disarranged. His inspiration was a mischievous puff of air that overturned habits and shook up the rules and formalities of the time. His wedding dress with a giant hood in place of a veil symbolized this spirit. It was made of finely pleated pink silk. The pink of pleasure rather than the white of virginity. Who could dare to refuse such an offer of freedom? Quite rightly, freedom represented for Kenzo a conquest of the spirit and a quest for the elsewhere.

Ever since leaving Japan, Kenzo traveled constantly: Peru, Africa, Greece, Egypt, India, Brazil, Bangkok, and Disneyland. Just as he had done on arriving in Paris, he plunged himself into the heart of each country, its customs and habits. He immersed himself in their traditions, without prejudices or reservations. He was not a hunter; rather, he was more like the hunted, allowing himself to be captured in the pleasure of understanding. Or simply of feeling. His collections were nourished by folklore, even though he would never use the word. He distrusted facile

picturesque or superficial interpretations. He assimilated and acclimatized. And when he discovered in a scholarly text (*Costumes, Their Cut and Form*) that "traditional costumes exhibit the technique of patchwork and their forms result in a flat and simple cut similar to that of the kimono," he felt overwhelmed. "Folk traditions from all over the world can go hand in hand," he thought, "my inspiration is in the arrangement." He borrowed his long shifts from Africa, his Mao tunics from China, his dresses worn over trousers from Vietnam; he designed flowers in the Japanese style and shawls with Aztec influences; he made Nehru jackets and infanta's robes as painted by Velásquez; he created long, voluminous dresses based on traditional festive costumes from Czechoslovakia and Romania; he even dared to stage the most compelling of fashion parades with a mingling of uniforms—military, ecclesiastical, and royal.

At the heart of this flamboyant cross-breeding lay a simple reality: Kenzo comes from Japan; he has lived in France for thirty years; he is neither completely Japanese nor exactly French; he lives in a happy equilibrium between the two countries. At last, he feels at ease everywhere. This explains his taste for the foreign and the permanent presence of the exotic in his collection: "I myself am exotic."

for Kenzo, fashion is a growing plant. It turns towards the future, like youth; grows towards the light, like the *Helianthus*, the American plant known to us as the sunflower. Was it just a magical coincidence, this connection with the titles of the magazines, *Sun* and *Sunflower*, that he used to devour before leaving Himeji?

But what of Kenzo today? To see him rush upstairs four steps at a time, crouch down for a fitting, burst out laughing when provoked, throw himself into art books like a child with a picture book, one might say that he has retained the behavior and pace of an adolescent. And it begins to

appear that pace is to the body what patience is to the spirit. And so, once again, we are reminded of the saying, "those who know how to wait. . . ."

In the late eighties and early nineties, fashion exploded in Paris and competition was extremely intense. From electric catwalk shows to light displays, Oscar presentations to showers of medals (for the arts), from proclamations to provocations, the media revelled in this pervasive intellectualism. The press kept Kenzo in the background, even though it remained mainly faithful to him. Did he suffer?

k enzo remained silent. He was careful not to betray himself or to give in to excesses or to passions. He was no more interested in taking part in the atmosphere of feverish excitement than in going against the current and sulking. Extreme oriental discretion took over. Or was it not, more simply, a case of extreme wisdom? One fine day, he finally recognized that he felt himself growing closer to the culture of his ancestors. This almost surprised him.

But Kenzo was not alone; nor has he ever been. Time, patience, and luck have conspired to produce some fortunate encounters. First of all, there was Atsuko Kondo, who stupefied him with the total confidence she had in him. Discreet, invaluable, and precise, Atsuko invented, designed, and stitched—with him and for him. Although Atsuko was forced to give up work because of illness, Kenzo still sees her. Now it is he who returns her loyalty and who keeps an eye on her.

Then came Gilles Raysse, an enthusiastic and generous friend. Half-joker, half-herald, he accomplished the tour de force of projecting Kenzo to the pinnacle of the fashion world. With him, the fashion parades became celebrations, catwalk spectaculars, whose gentle irony, plentiful ideas and, above all, joyful atmosphere were without precedent. Fame, it is said, feeds on itself, but fame without profit does not last long.

It was after him that Xavier de Castella entered Kenzo's life and joined in the emotion of creativity. He had class, fine culture, a joyous vitality—and good business sense. Very soon he called in François Baufumé, who firmly believes that "the hen that cackles the loudest is not necessarily the best layer." Straightforward, unpolished, Baufumé acts quickly and reacts in a dry manner. Together, the team succeeded in relating the ephemeral event of the collections to the long-term needs of the business. Since fashion gets carried away on the catwalk, Kenzo was thus able to step aside, take a parallel track and give free rein to his imagination once more.

In 1983, Kenzo created his first ready-to-wear collection totally and specifically for men. From Prince-of-Wales-check suits in pure wool to technicolor socks, from striped shirts to woolly sheepskin jackets, from trench coats to spencers, he excelled at a style that was simultaneously relaxed and serious.

●

I n 1988, his first perfume, like those that followed, became an integral part of Kenzo's fashion. His creations, laden with a thousand memories, inspired new cross-influences. From *Kenzo* to *Jungle Éléphant* and *Jungle Tigre*, there has been no lack of new discoveries—right up to the most recent, combining limetta oil (between lemon and lime), *maté* from Brazil, Indonesian nutmeg, benzoin gum from Tonkin, guaiacum resin from Central America, cedar from the Atlas mountains and from Lebanon.

From East to West, through squalls and bright intervals, turbulence and calm, without the wind ever dropping or turning, the house of Kenzo was constructed—a House with a capital H. In fact, it represents a veritable empire, consisting of almost one hundred and fifty boutiques, of which twenty-two carry the name of Kenzo, in more than twenty of the world's great cities.

Where is the flagship of the business? The boutique on the Place des Victoires in Paris. And where is the invisible machinery behind the fashion empire? Montbazon (Indre-et-Loire) is its logistical center, warehouse and administrative office, with sixty information terminals. From here, seventy percent of Kenzo's production is exported to eighty different countries.

One could stop there, with the French success of a small Japanese man with a huge talent. One could finish on the fashion glory, the collective expression, mirror and reflection of an era, which had made him famous since his first arrival in Paris. However, that would be incomplete. Kenzo created another house: the one in which he lives. In truth, his friend Xavier de Castella, who trained as an architect, designed and built it: a very large space, but with nothing ostentatious or overwhelming. It is a place for relaxation, for resting after work or travel; somewhere to meet and be convivial; a place for silence and contemplation—an "oasis-house," as Kenzo likes to call it.

here he has arranged his collection of travel souvenirs, "must-have" purchases, objects from all over the world: Japanese screens with delicate fish; elephant-chairs—or chair-elephants, if you like—from Indonesia; an African statue; enormous vases from Japan, China, Scandinavia; a table from the Philippines; a door from an age-old Indian palace, complete with a beautiful design of a tiger, of course, and hung on the wall like a picture; a piece of Japanese kitchen furniture; a whole range of dishes, from China, Japan, Sweden . . . and France.

It is most striking that this decor, composed of objects from so many different places, does not in any way resemble bric-à-brac. Just like his fashion, there is not a single false note; each object seems to be there quite

naturally, in its place. And yet, at the same time, nothing is fixed: things can move, come closer together to make room for others, leave and return—just like his designs. A simplicity of form permits every combination and makes the colors blossom.

With Kenzo, everything is suggested, nothing is imposed. A woman wearing Kenzo clothes is never "dressed," and certainly not disguised. She falls in love with a dress and then moves on. A desire is fulfilled by putting together a jacket here, a blouse there, and completing the outfit with a scarf. With this playful notion of fashion, Kenzo has laid the foundation for sharing pleasure. Out of it he has created a game without frontiers. Therein lie his difference and his modernity. His fashion is always at a crossroads, a favored place of encounters and exchanges. And so he projects us into the twenty-first century, free of anything weighty or showy, somewhere between globalism and globalization.

For an even deeper understanding, it should be noted that a smaller house is joined to the large one; an authentic tea house with a Japanese garden. As you arrive, you are immediately surrounded by a feeling of freedom, almost of lightness. The cherry tree whispers to the bamboo. The water cascades over the rocks into a carp pool.

The lapping of water, the rustling of leaves: Kenzo goes there to meditate or to look at the stars from the little balcony with its bamboo floor. There he sustains his strength . . . and his great patience.

The freshening wind
turns and turns about again
and now it is here.
Kobayashi Issa (18th century)

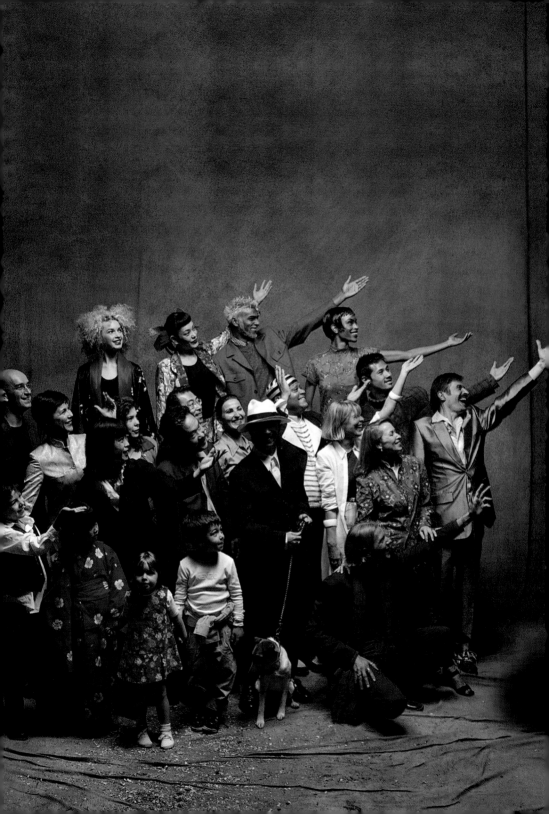

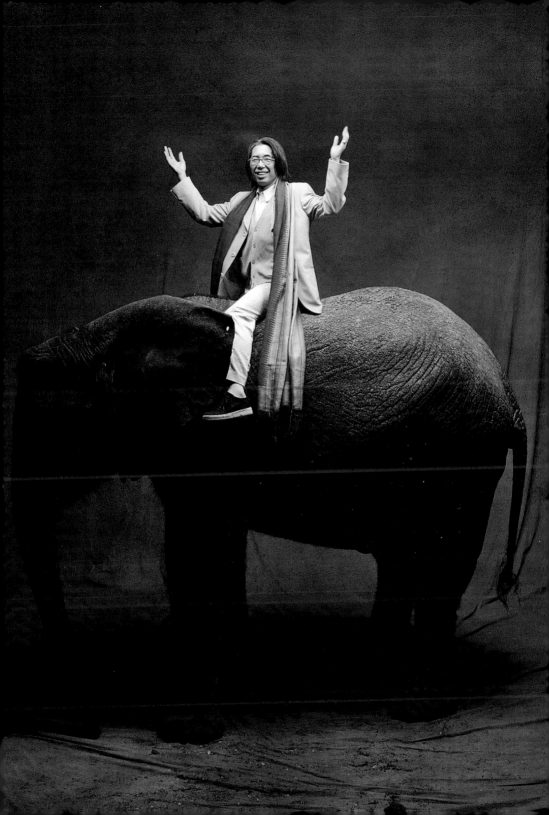

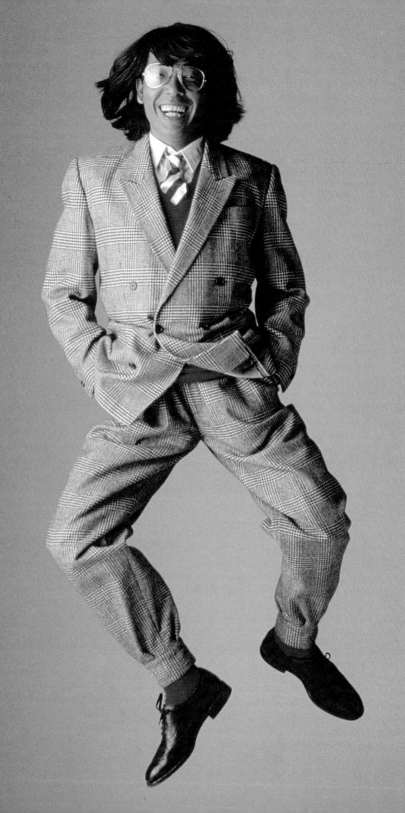

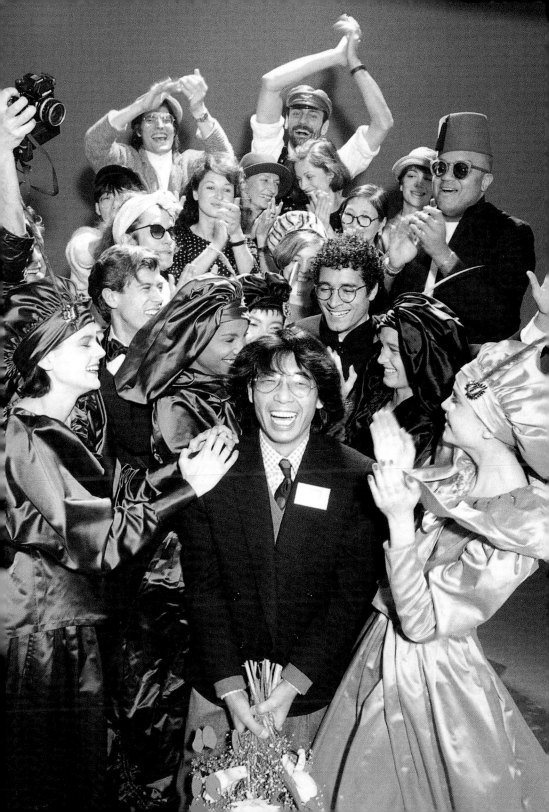

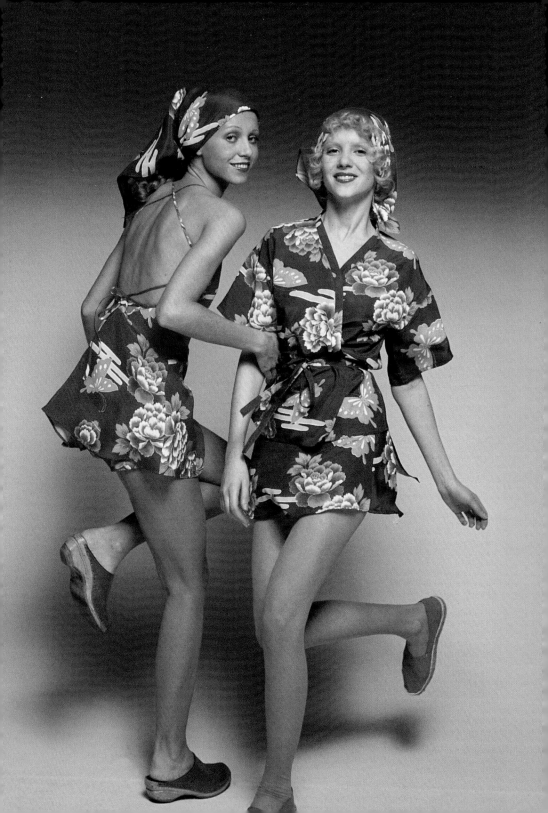

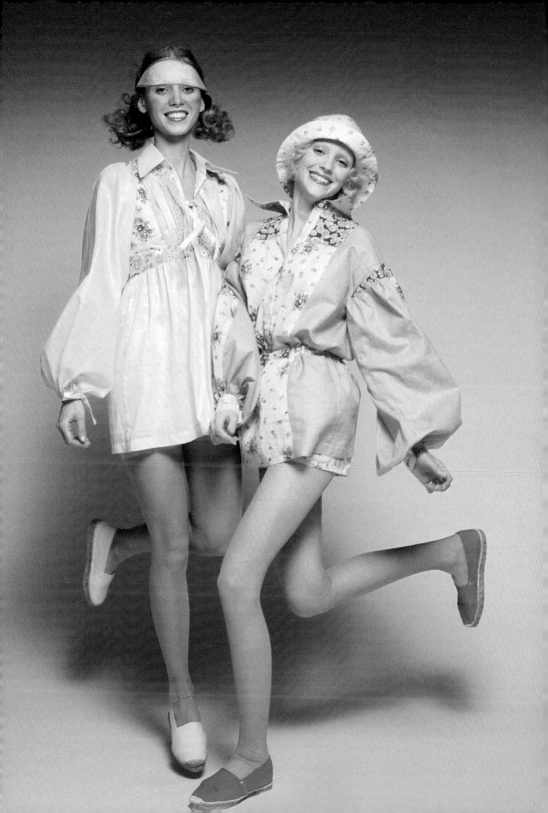

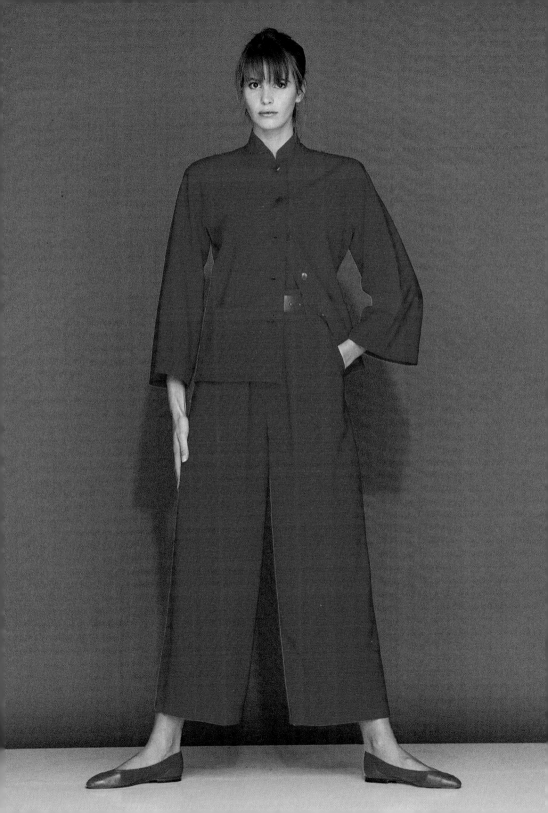

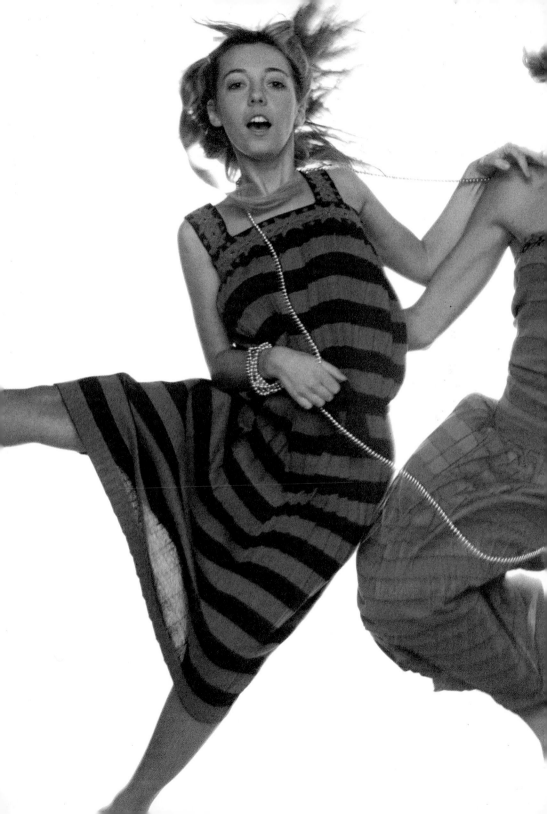

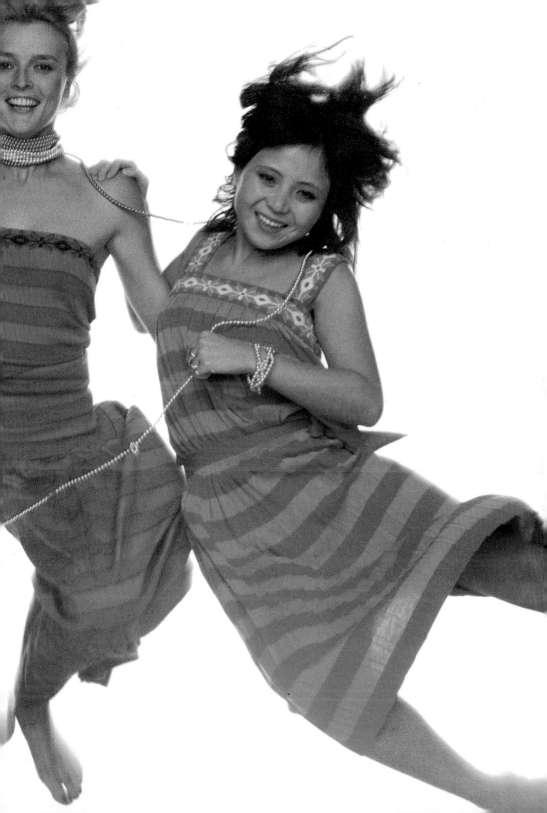

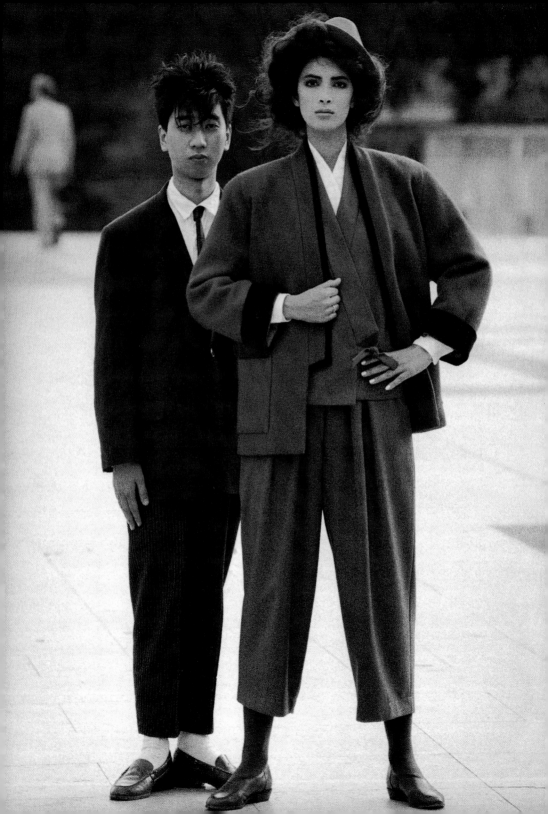

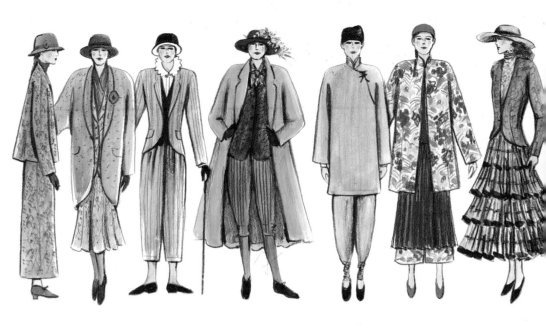

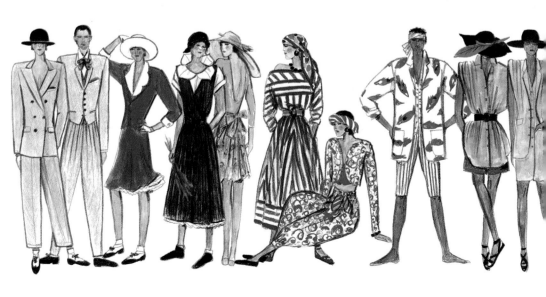

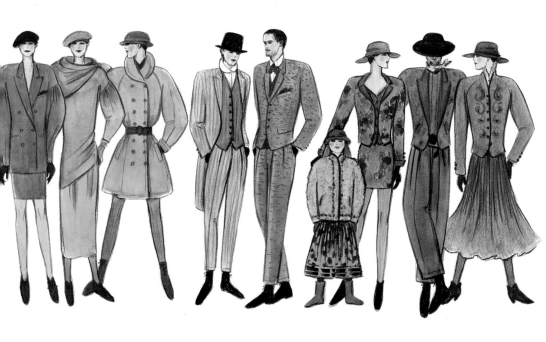

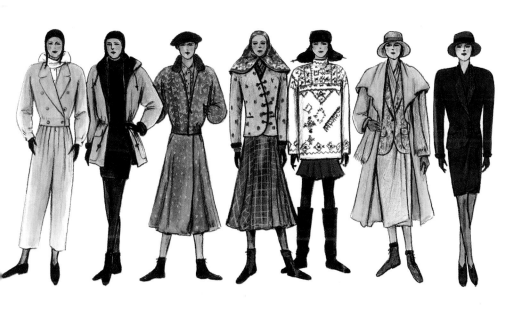

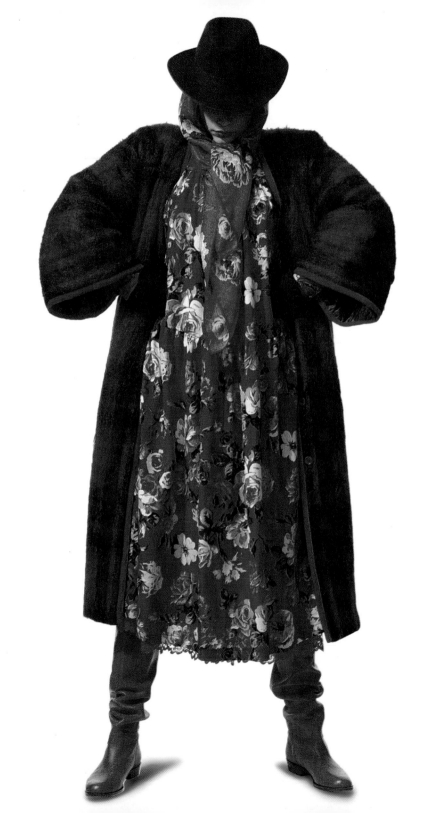

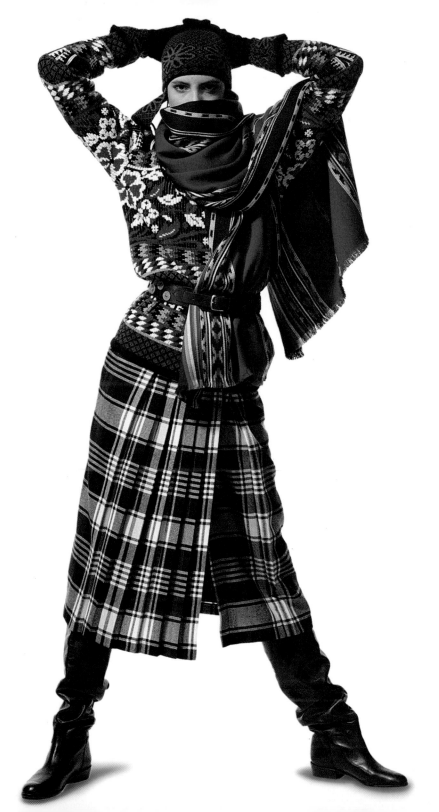

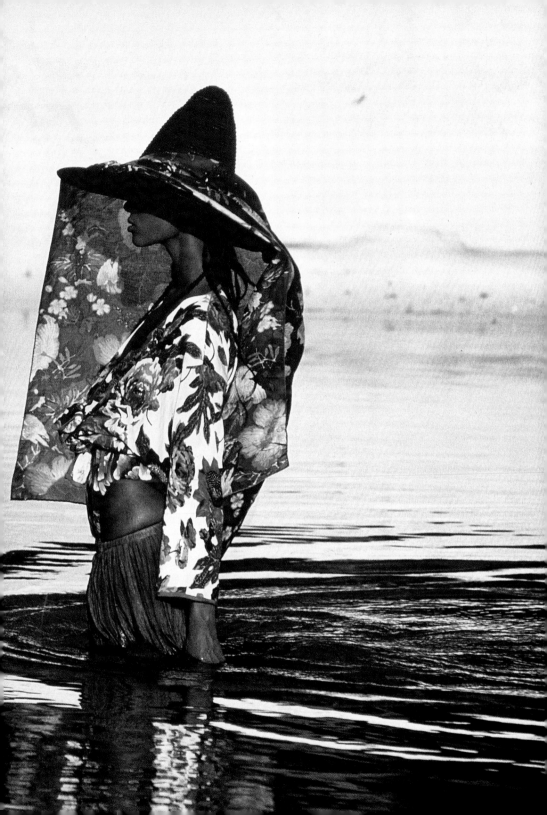

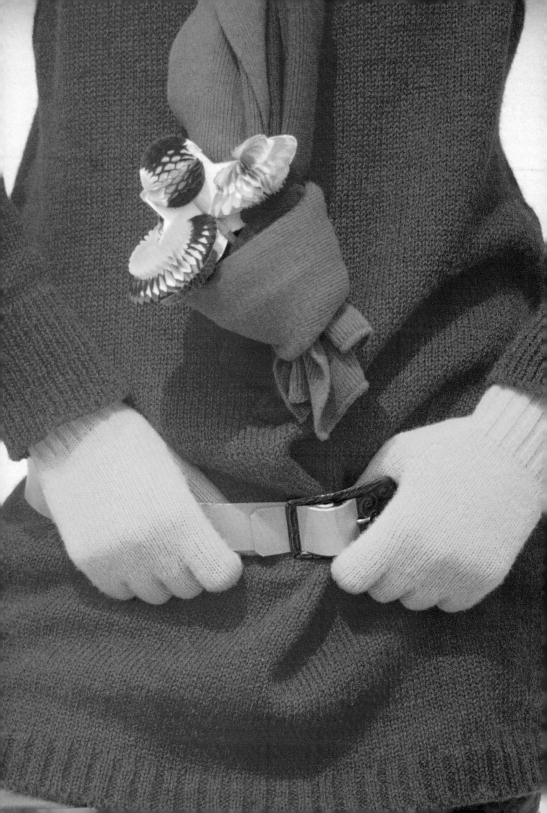

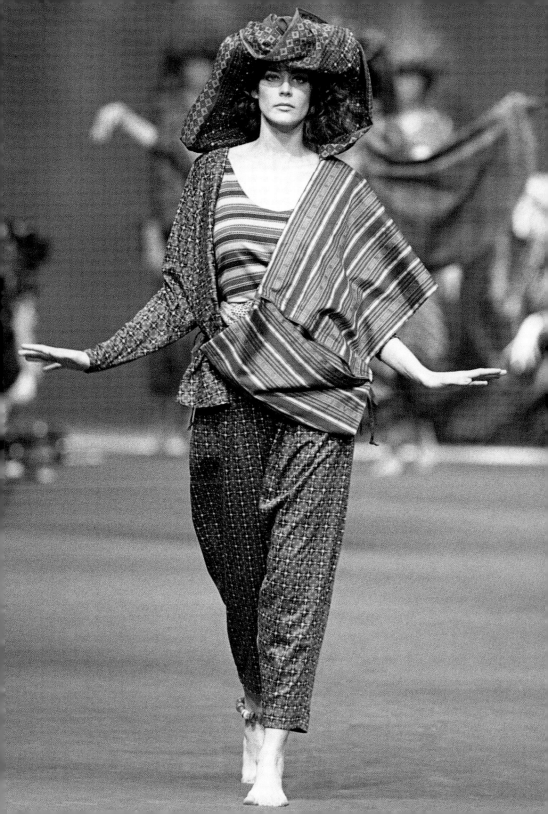

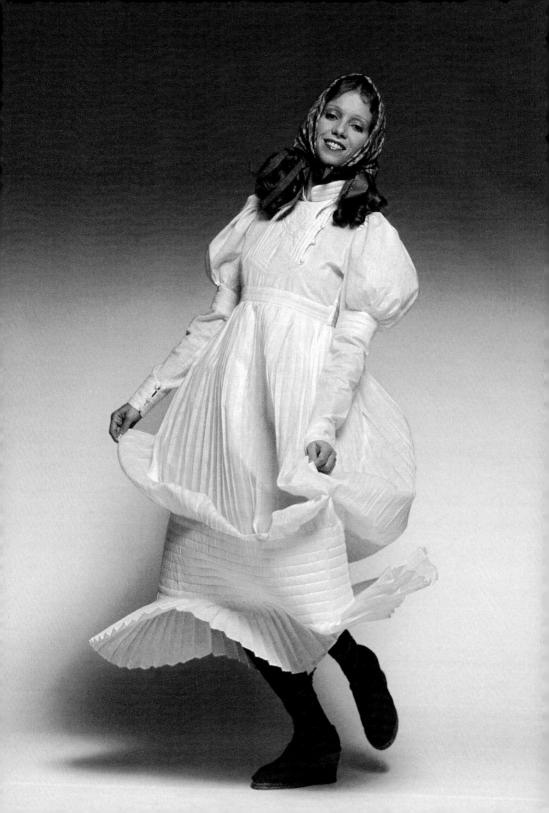

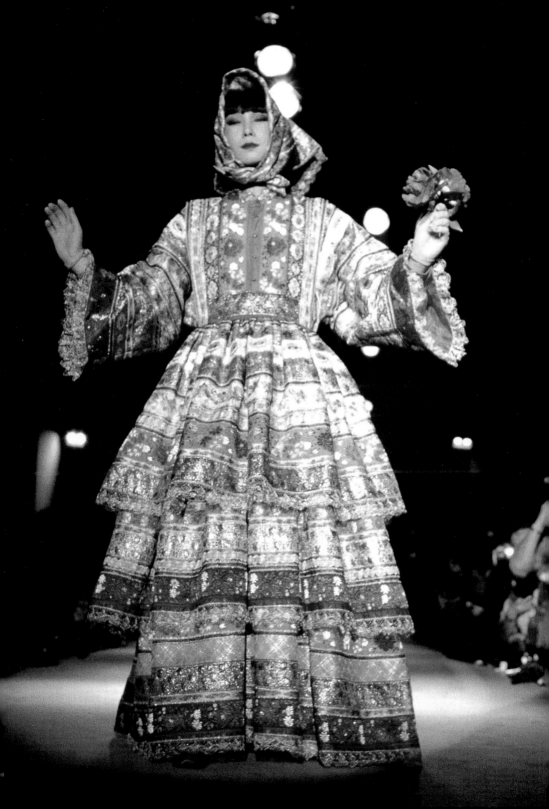

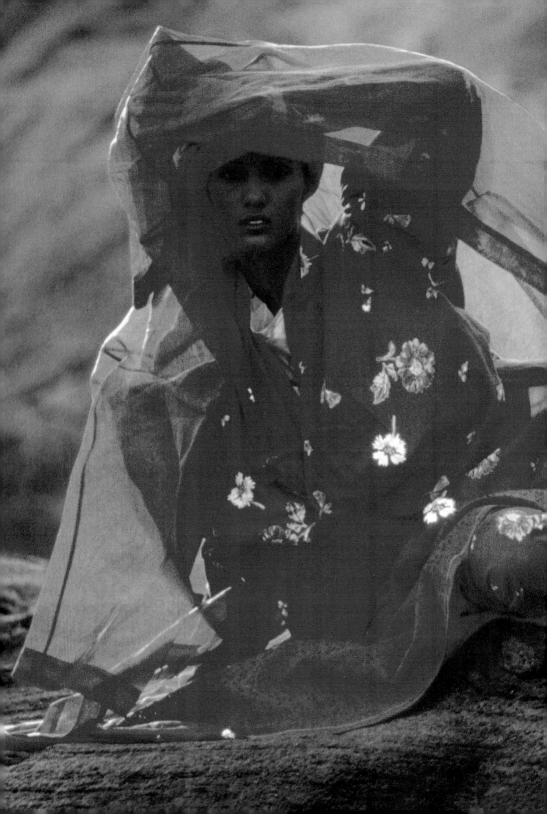

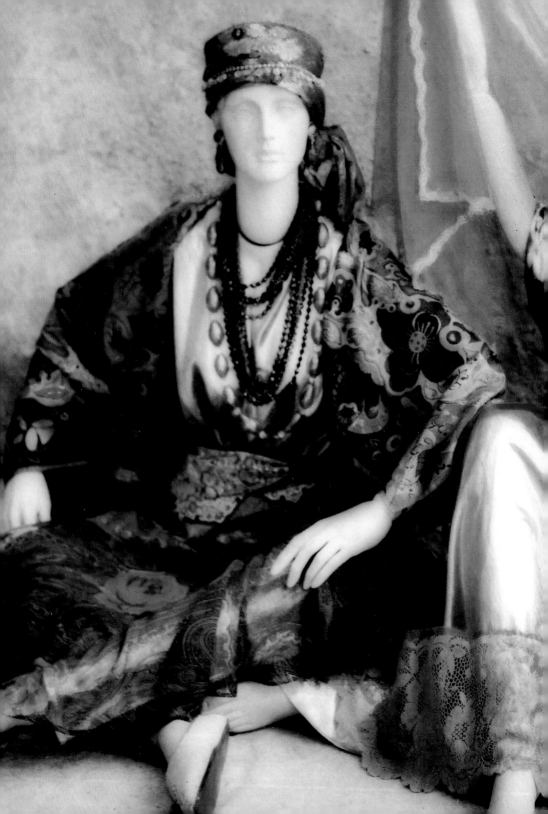

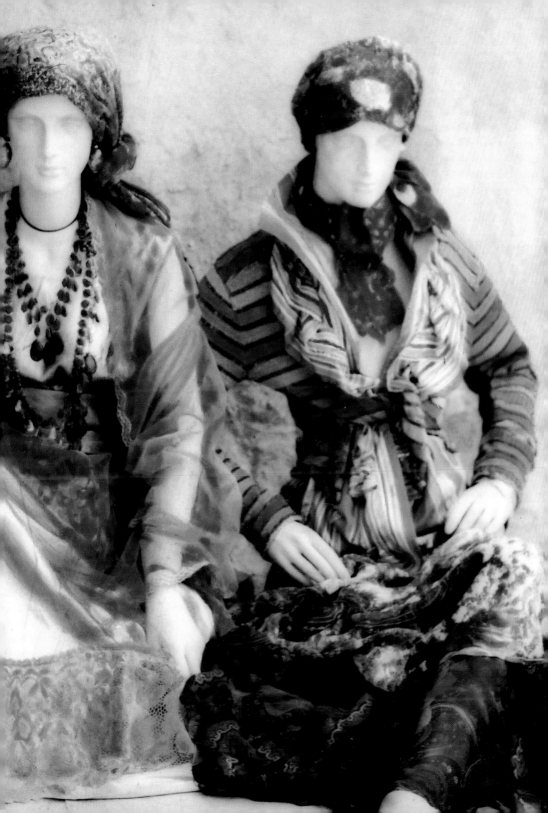

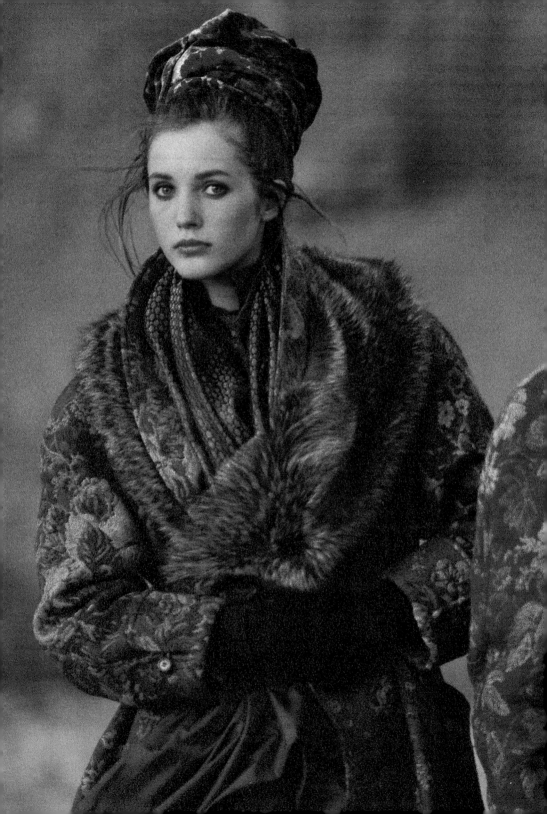

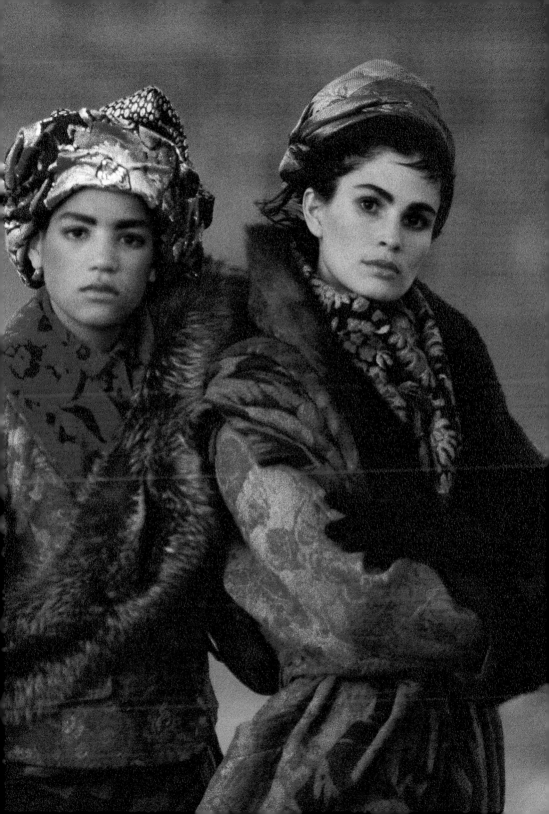

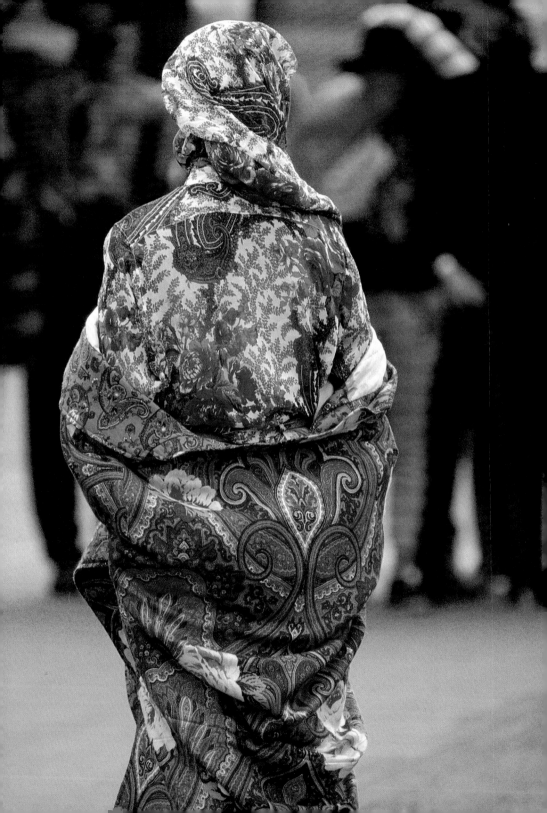

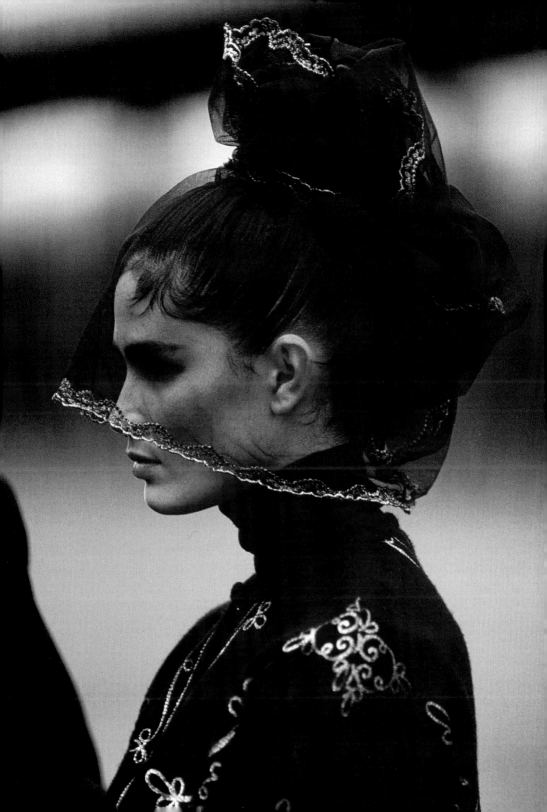

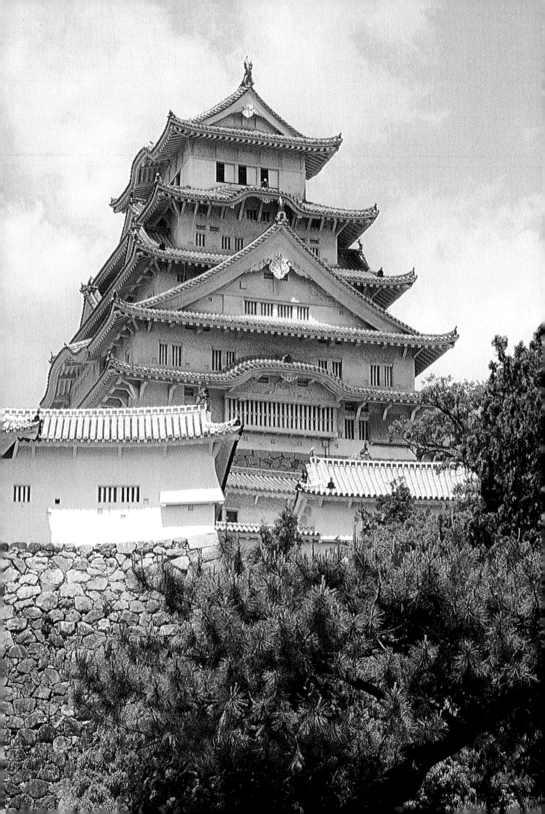

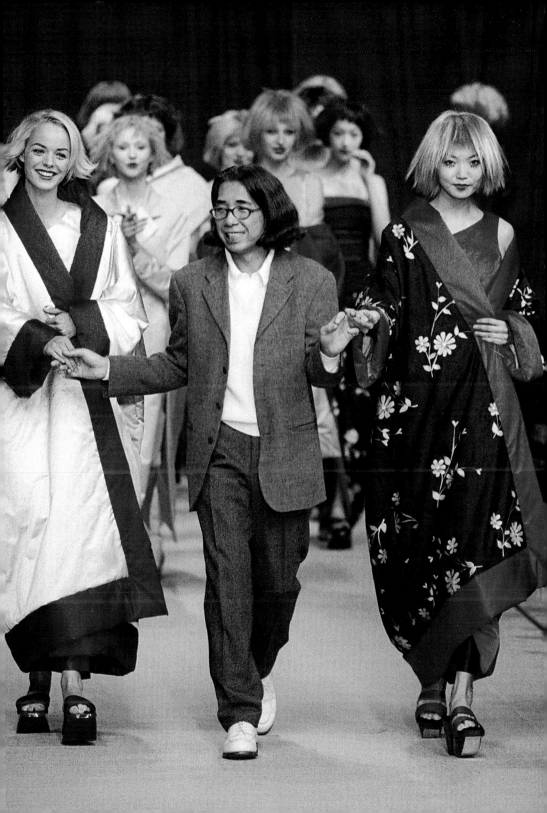

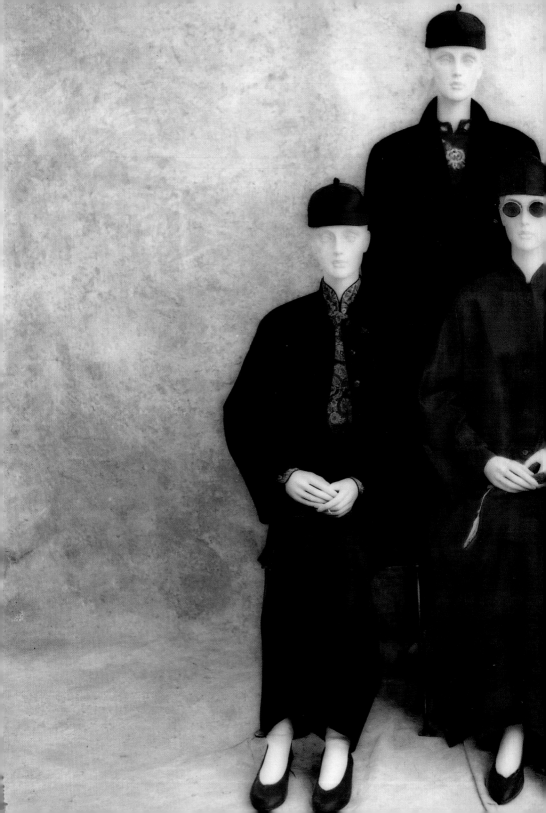

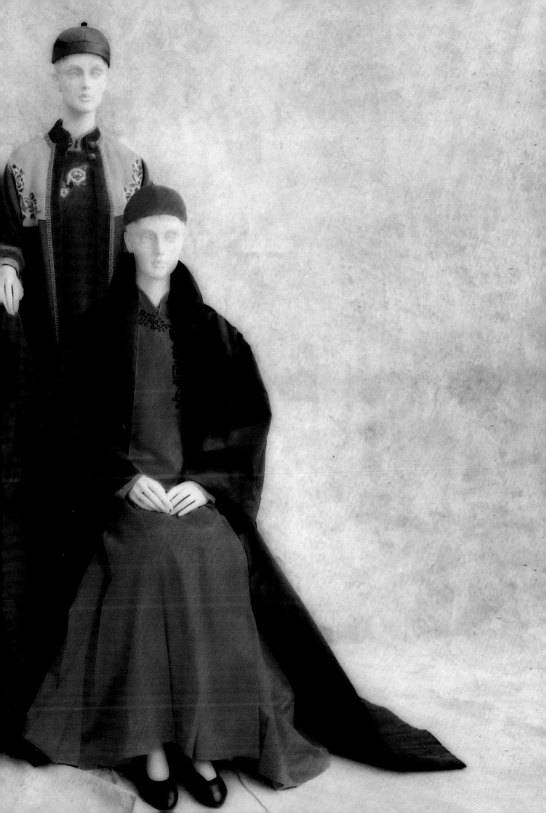

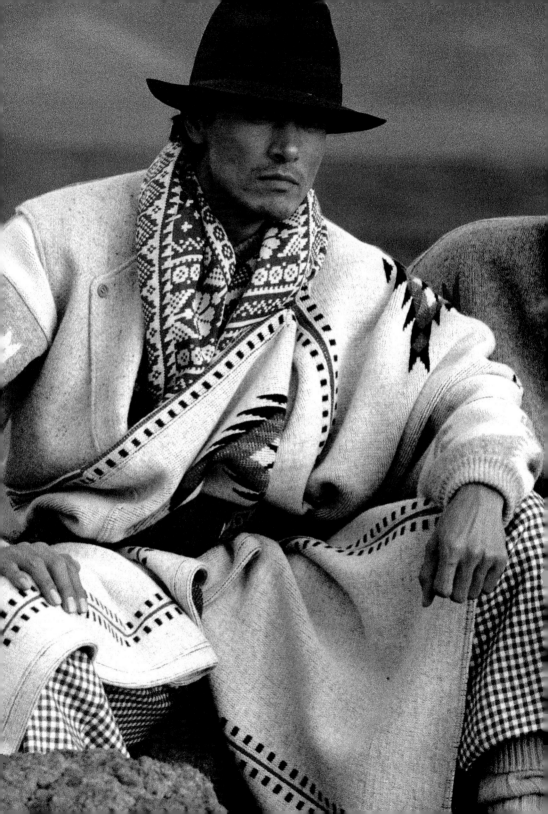

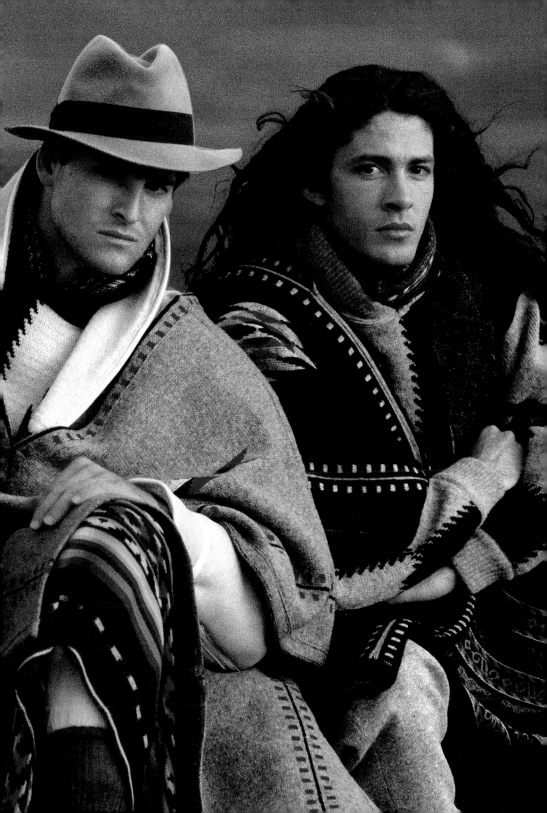

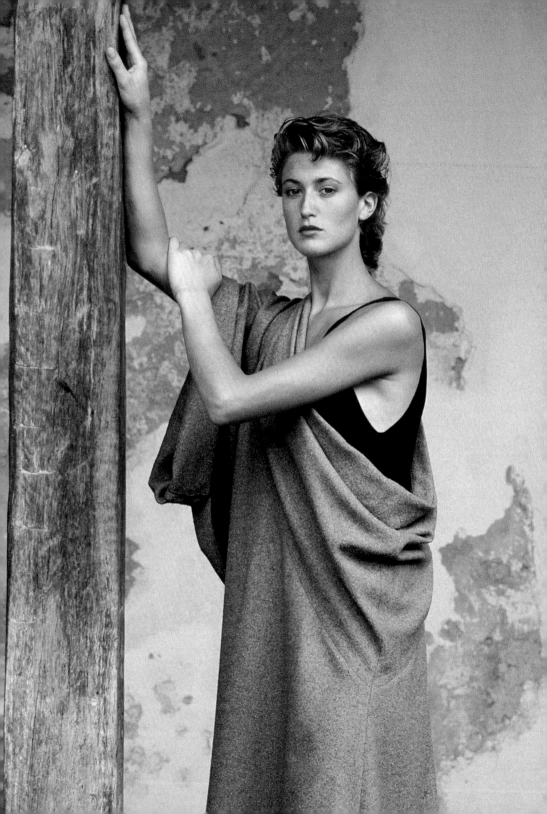

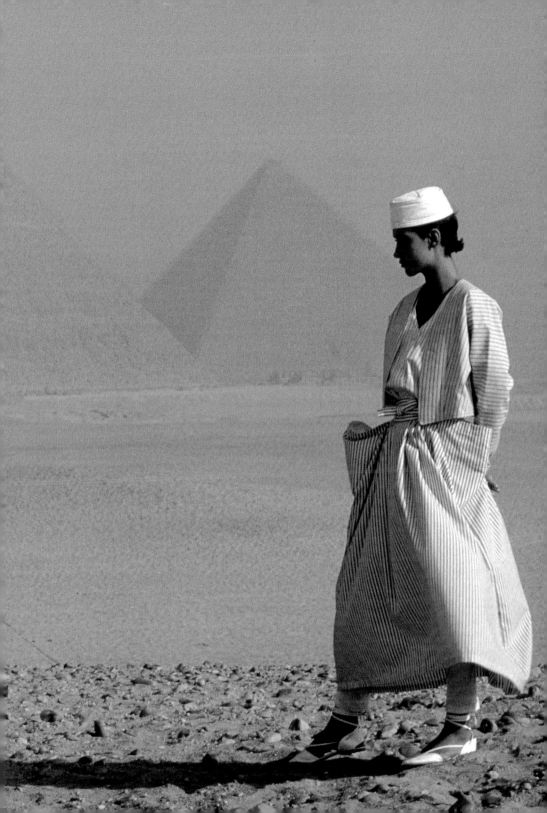

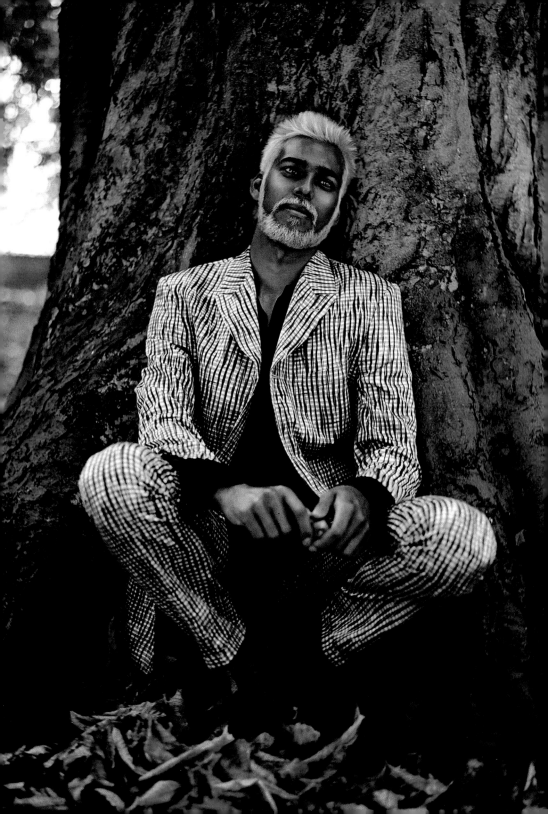

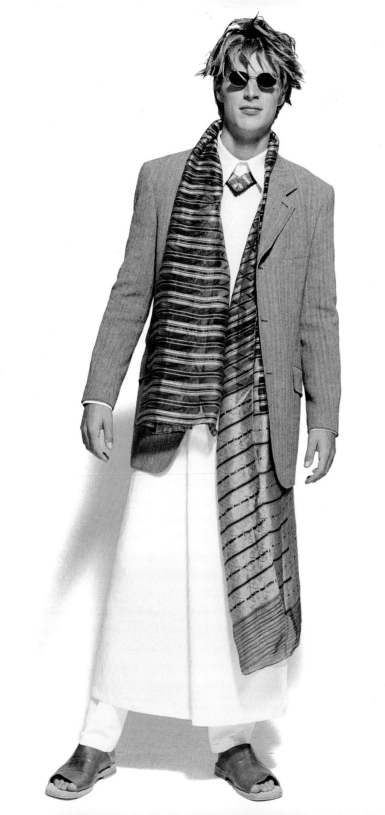

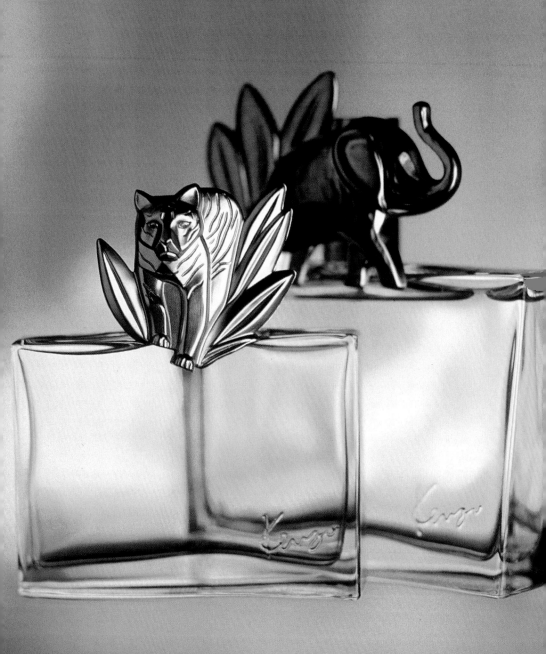

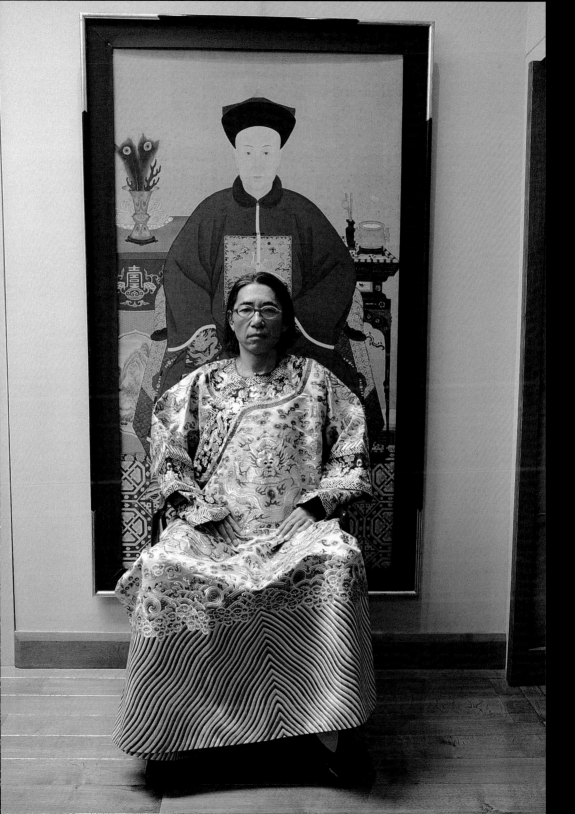

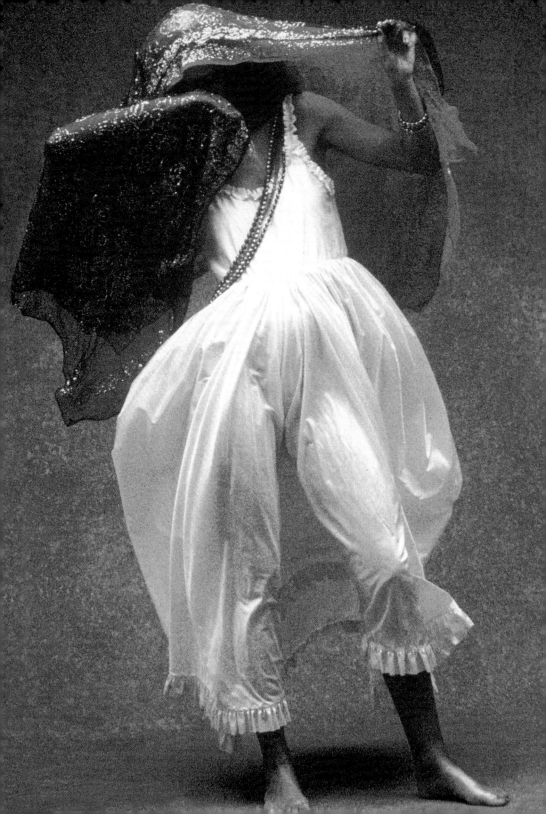

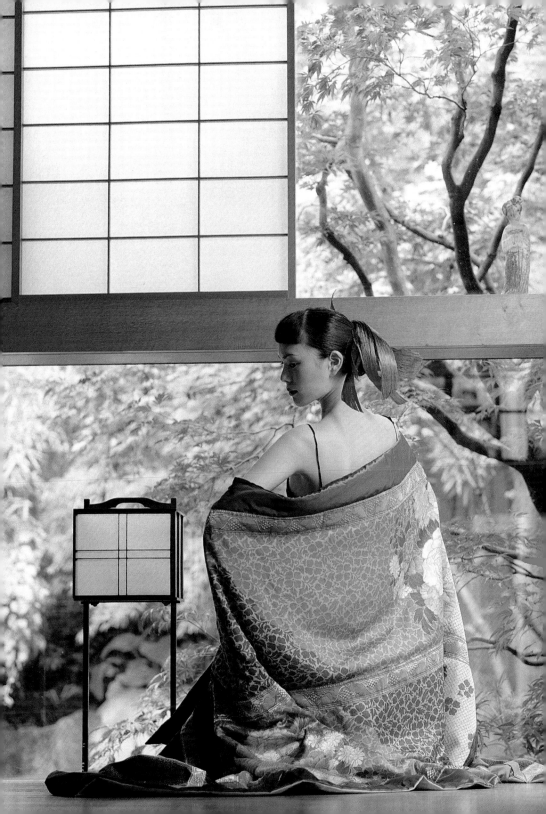

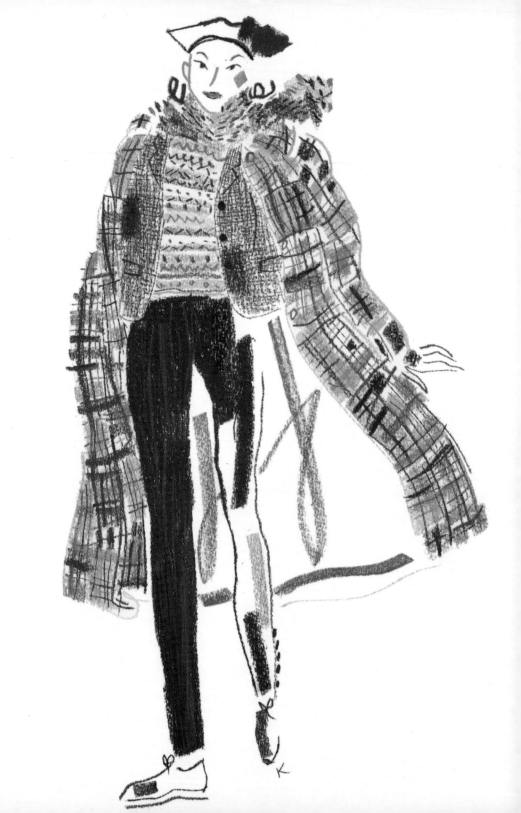

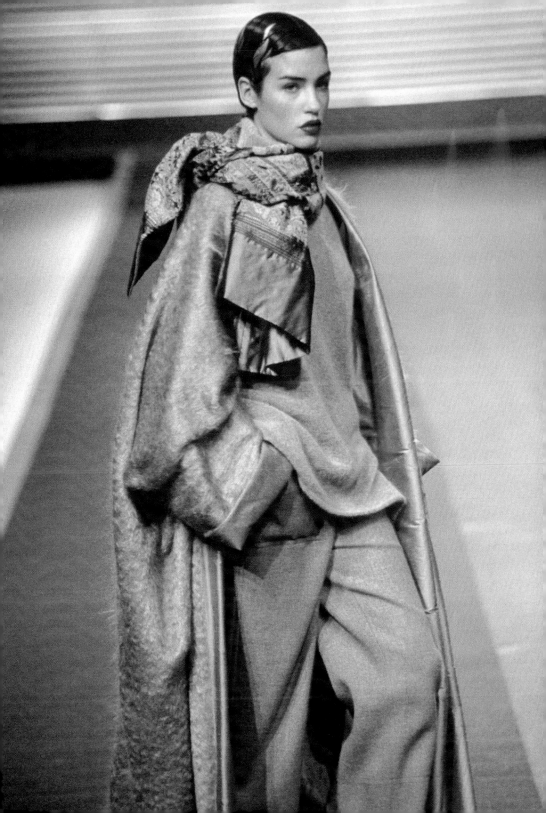

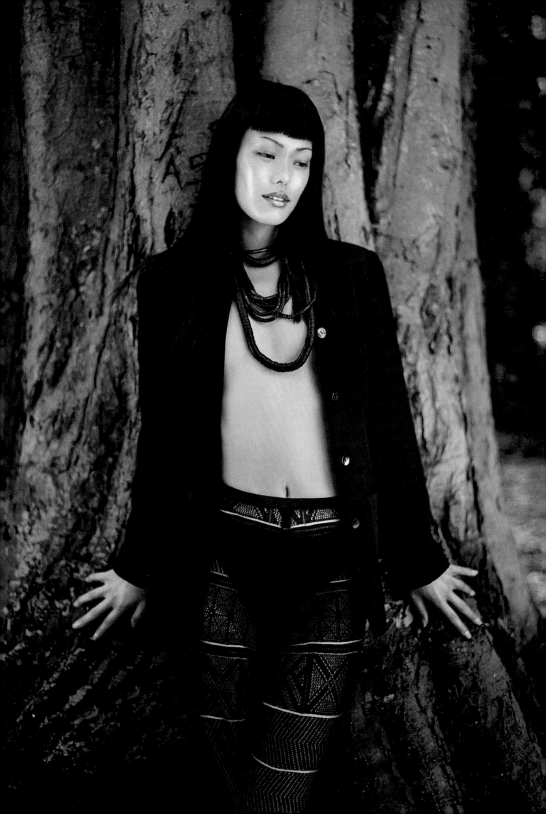

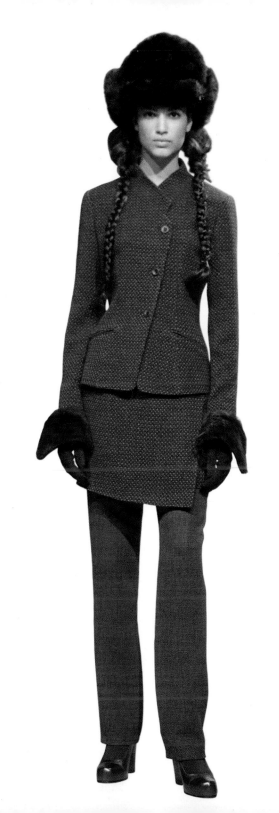

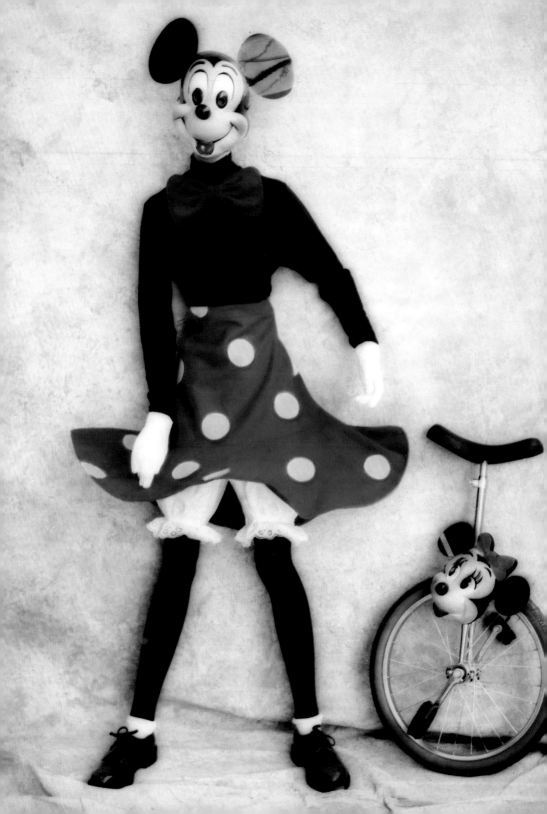

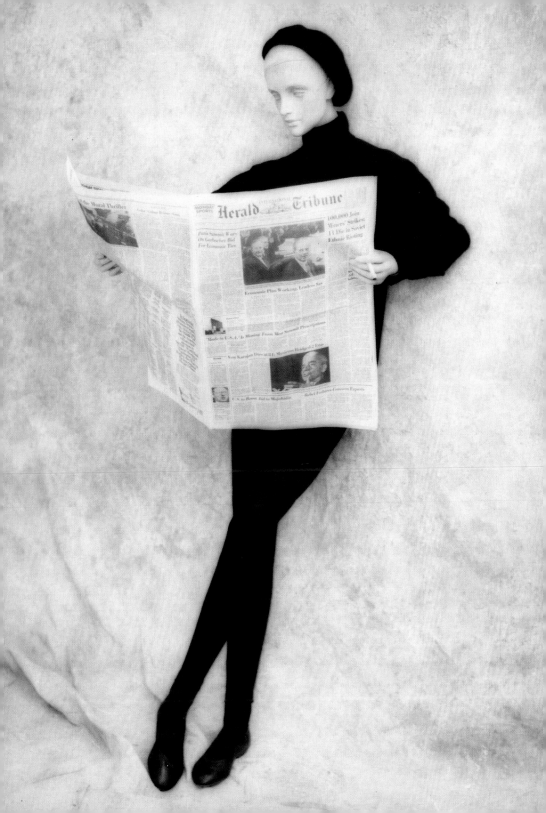

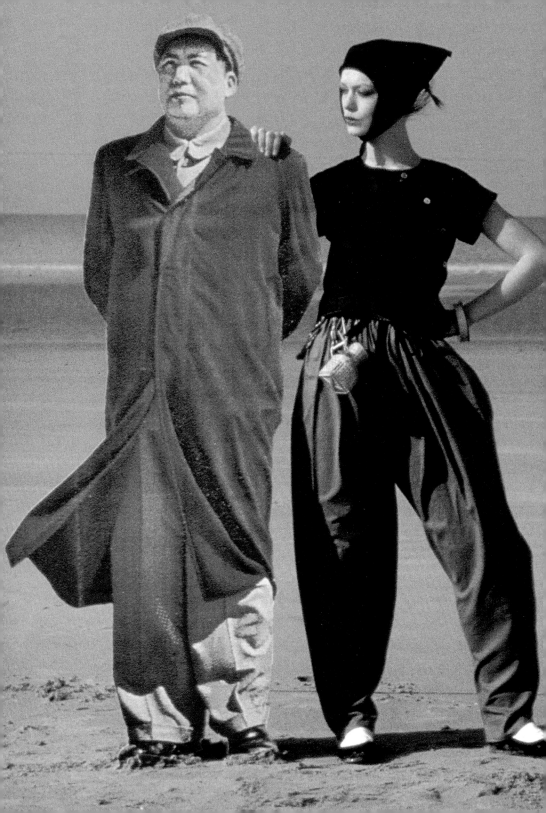

Chronology

1939 February 27, Kenzo Takada is born in Himeji, Hyogo (Japan).

1958 Kenzo is one of the first male students admitted to the Bunka Gakuen in Tokyo, a prestigious school of fashion.

1965 January 1, Kenzo arrives in France, at Marseilles, after a sea voyage of one and a half months.

1970 The first show at the boutique Jungle Jap, in the Galerie Vivienne (Paris), takes place in April. Following the release of this collection, *Elle* features Kenzo on the front cover.

1971 Another show in the Galerie des Champs (Paris) in April. This collection, also presented in New York and Japan, brings Kenzo international fame.

1972 Kenzo is awarded the Fashion Editor Club of Japan prize.
In April, he presents another show inside the Gare d'Orsay (Paris). The crowds are so large that it has to be cut short.
In October, holds his first show in the Bourse du Commerce (Commodity Exchange), Paris.

1975 June sees Kenzo's first large show in Tokyo with his "Chinese" collection. Eighteen thousand people attend in two days. Afterwards it is also shown in Kyoto.

1976 Kenzo moves to the Place des Victoires in Paris: the boutique and studio are reunited once again.

1977 In September, Kenzo stages a show for the opening of Studio 54 in New York. Grace Jones, a friend of the designer, sings "I Need a Friend" for the first time in public.

1978 In March, a show is held in a big top at Porte Maillot (Paris). The guests are greeted by a fairground band. The electric atmosphere culminates with the entrance of a horse with a female rider in transparent uniform.

1979 Kenzo creates the costumes for Stockhausen's operatic ballet *Der Jahreslauf* (The Course of the Year), presented at the Salle Favart (Paris).
In April, show at the Knie circus in Zurich. Kenzo appears in the finale riding on an elephant.

1980 Kenzo makes a film entitled *Rêve après rêve* (Dream after Dream).

1981 In October, the Place des Victoires (Paris) is covered over for a show, with a firework display above the statue of Louis XIV.

1983 Launch of the menswear collection.
Opening of Kenzo's boutique on Madison Avenue, New York.
A show takes place in October in the gardens and on the terraces of the Château de Maisons-Laffitte (Yvelines), which are covered with transparent marquees. The evening ends with fireworks and a party in the château.

1984 November 19, Kenzo is made a Chevalier de l'Ordre des Arts et des Lettres by Jack Lang, French Minister of Culture.

1985 The Bunka Publishing Bureau produces a volume on Kenzo, covering ten years of creativity.
He receives the Mainichi Fashion award.
In June, Kenzo presents the show "Fairy Tale" at the Budokan (Tokyo), in front of 7,000 people.

1986 Opens his first boutique for men in Paris, at 17, Boulevard Raspail.

1987 In July, the big catwalk show "Man and Woman" is staged in Tokyo and Osaka, in collaboration with Fuji (80 models, 180 entrances).
A big show at the Cirque-d'Hiver (Paris) takes place in October.

1988 In June, Kenzo launches his fruity, floral perfume for women, *Kenzo*.

1989 In May, the museum of Himeji, Kenzo's birthplace, organizes an exhibition of his work.

Mao's China. Photomontage produced for Elle magazine. Designs by Kenzo: wide trousers and loose blouse buttoned in Chinese fashion. Spring/Summer 1975 collection.
© Photo: Jean-Bernard Naudin/Elle/Scoop.

At the same time, Kenzo stages a huge catwalk show in front of the castle of Himeji, with more than 21,000 people attending over three days (70 models, 420 entrances).

Ginette Sainderichin's book *Kenzo* is published by Éditions Du May, tracing the history of twenty years of creativity.

In September, Kenzo's exhibition in the Seibu department store, Tokyo.

"Kenzo Maison" line launched.

1990 October 21, Kenzo celebrates twenty years of his career in Paris at the École Nationale Supérieure des Beaux-Arts (ENSBA). On this occasion, Kenzo announces the setting up of a new chair intended to fund the appointment of a foreign artist of repute to teach at the School.

Presentation of the Spring/Summer 1991 collection at the ENSBA.

A Kenzo boutique opens in Hong Kong in November.

1991 In March, work on the new logistical center at Montbazon begins. Some 10 kilometers (6 miles) from Tours, the buildings cover 20,000 square meters (215,000 square feet) situated in 10 hectares (25 acres) of orchards.

In June, the new fragrance *Kenzo pour Homme* is launched, with a fresh hint of the sea.

1992 March 21, presentation of the sumptuous collection of Kenzo's kimonos at the Ritz hotel (Paris).

In May, a tour of Asia: shows in Bangkok, Taipei, Singapore, Bali, and Jakarta.

July 14, during the World's Fair in Seville, Kenzo produces a show in the bullring as part of a spectacle bringing together eleven different couturiers and four *créateurs de mode*.

In September, launch of the second perfume for women, *Parfum d'Été*, a green, floral scent.

In October, shows in Tokyo on the occasion of the tenth anniversary of the Treaty of Friendship, linking the city with Paris.

1993 In April, a new Kenzo boutique opens in London.

In November, Kenzo takes part in the exhibition organized for the celebrations of the seventieth anniversary of the Bunka Gakuen school of fashion in Tokyo.

1994 To celebrate the first day of summer, June 21, Kenzo gives the Parisians a special treat, dressing the Pont Neuf with flowers.

Autumn/Winter 1994/1995 show at Himeji, Kenzo's birthplace.

Launch of *Kashaya*, an oriental perfume for women.

1995 In March, a Kenzo boutique opens in Sydney, Australia.

March 18, presentation of the Autumn/Winter 1995/1996 womenswear collection at the Opéra Garnier (Paris).

In May, Kenzo tours Asia, with shows in Singapore, Shanghai, Hong Kong, Taipei, and Seoul.

In September, a new Kenzo boutique opens in New York.

Launch of the limited-edition Kenzo Twingo: Kenzo uses flowers and colors to revamp the famous car.

1996 In April, launch of the women's perfume *L'Eau par Kenzo*, a new fresh, sensual fragrance.

In May, Kenzo creates a Japanese garden as part of the event "The Art of the Garden," in collaboration with *Elle* magazine.

In September, Kenzo launches the spicy, new-age, women's perfume *Jungle Éléphant*.

1997 January 26, presentation of the Autumn/Winter 1997/1998 menswear collection at the Buddha Bar (Paris).

In March, launch of the floral, springlike women's perfume, *Le Monde est Beau*.

In September, launch of the women's perfume *Jungle Tigre*, a flowery, woody fragrance.

1998 In March, launch of the woody men's fragrance, *Jungle pour Homme*.

In November, for the fifth annual ceremony of the Time for Peace Awards, Kenzo is chosen to create the Dress of Peace, 1998. This garment is intended to be worn in February 1999 at an evening event in New York, when the newly created Time for Peace Fashion Award is presented to the designer.

The nobility of linen, the freshness of cotton, the relaxation of summer, a timeless elegance. Spring/Summer 1995 collection. © Photo: Pascal Therme.

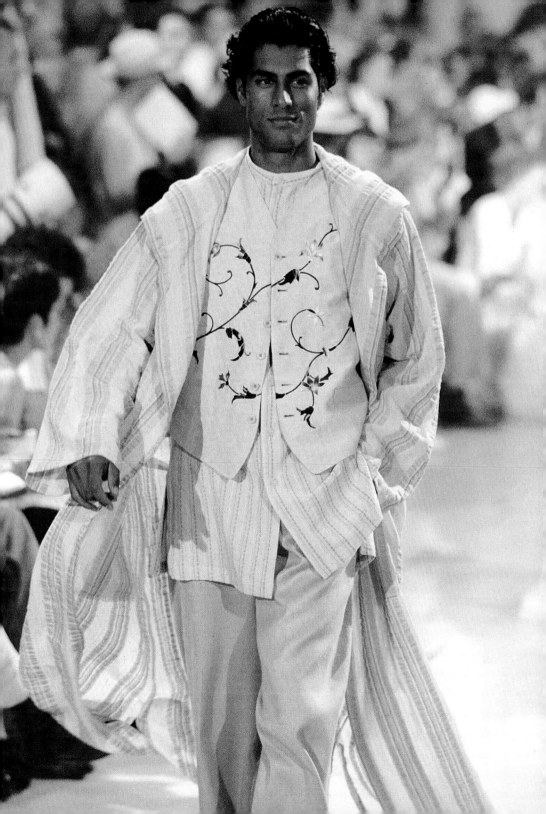

Kenzo

The team, my elephant, and me. Do any nonsuperstitious people exist? Long ago, Kenzo decided that the elephant was his lucky mascot. There are dozens of them in his house: in wood, bronze, and porcelain, reproduced on carpets and other objects. His collaborators are delighted, paying tribute to the wisdom of Asia. © Photo: Jean-Marie Périer/Elle/Scoop.

"Jungle Jap." Fur knit, with the mysterious gaze of Kenzo's star model, Sayoko: feline eyes for a bewitching tigress. Autumn/Winter 1983/1984 collection. © Photo: Hans Feurer.

Kenzo in a Prince-of-Wales-check suit, with golfing trousers and cashmere V-necked pullover. © Photo: Denis Broussard/Elle/Scoop.
Finale of the Autumn/Winter 1984/1985 show. Pure jubilation for Kenzo, his models, his collaborators, and his friends. © All rights reserved.

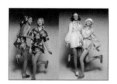

Spring of fashion, spring of life. The floral dresses of youth. Kimono fabric with peonies in full bloom (left) and pastel percale and Pompadour prints (right). Spring/Summer 1971 ready-to-wear collection. © Photos: Gilles Bensimon/ Elle/Scoop.

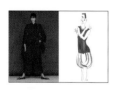

Kenzo's *bon chic*. Jacket with Mao collar and wide trousers cut above the ankle. Spring/Summer 1987 collection. © Photo: Gilles Bensimon/Elle/Scoop.
Illustration by Keiko Nagata. "Orientalist" silhouette in linen and silk in spicy colors: sleeveless top and baggy *sarouel* trousers. Spring/Summer 1992 collection. © All rights reserved.

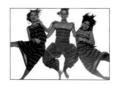

A light, easy, relaxed fashion. For these garments, Kenzo used a jersey cotton that had previously only been used for T-shirts. The whole spirit of his fashion lies in this sense of ease and lightness. Spring/Summer 1979 collection. © Photo Oliviero Toscani/Elle/Scoop.

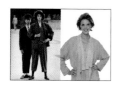

Classic Kenzo is never conventional. Kimono forms used for a tweed suit with trousers cropped short. Autumn/Winter 1982/1983 collection. © Photo: Peter Lindbergh.
More kimono influence: silk and viscose blouses in pastel shades, whose juxtaposition expresses a kind of freedom. Spring/Summer 1997 collection. © Photo: Jean-Marie Périer/Elle/Scoop.

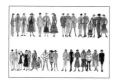

The precision of line and detail. Kenzo's drawings for invitations to his catwalk shows. From left to right, above and below, the collections are: Autumn/Winter 1989/1990, Autumn/Winter 1988/1989, Spring/Summer 1988, Autumn/Winter 1990/1991. © Kenzo Archives.

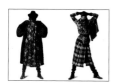

Flowers go with everything, everywhere. A voluminous braided coat, in mohair and wool, over a floral dress and matching scarf. Autumn/Winter 1984/1985 collection. © All rights reserved.
Mixing and layering. The checked skirt, flowery sweater, broad-striped scarf, and patterned hat and gloves combine in the spirit of ikebana.

Escape, islands, the tropics. Midriff in the air and feet in the water. Baggy silk *sarouel* trousers, printed-knit cardigan knotted in front, tulle scarf over a pointed hat. Spring/Summer 1985 collection. © Photo: Hans Feurer.

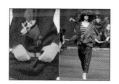

The brilliance of colors. Tunic jumper in Indian pink; golden yellow gloves and belt. Autumn/Winter 1976 collection. © Photo: Oliviero Toscani/Elle/Scoop.
Oriental simplicity. Striped top with jacket and trousers in discreetly printed jersey, and stole folded over, like a monk's habit. Spring/Summer 1986 collection. © All rights reserved.

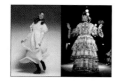

The brides were so modest and pretty! High neckline, pleats overall, leg-of-mutton sleeves, effects of volume. Spring/Summer 1971 collection. © Photo: Gilles Bensimon/Elle/Scoop.
For a Russian-doll bride, nothing but braids and ribbons sewn edge to edge in a juxtaposition of colors and graphics. Autumn/Winter 1982/1983 collection. © All rights reserved.

Transparent, flamboyant red. In printed cotton, strewn with flowers, a *broderie anglaise* slip and fitted trousers. The espadrilles are also red, but nothing is forced: you can choose, pick, and combine in different ways. Spring/Summer 1983 collection. © Photo: Hans Feurer.

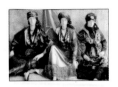

"The Gypsies." One of the themes chosen for the exhibition "Liberty," organized by Kenzo in 1989 in Tokyo at the Seibu department store. An example of Kenzo's fusions: the look has been created by combining elements taken from collections dating from 1974 to 1987. © Photo: Marianne Chemetov.

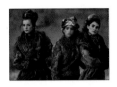

Flowers even in winter. Coats with fur collars, wool jackets lined with cotton, scarves, and turbans; graphics, flowers, and colors all mixed together. Autumn/Winter 1985/1986 ready-to-wear collection. © Photo: Peter Lindbergh.

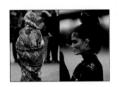

Son et lumière: **when colors vibrate.** A 100% viscose paisley-pattern printed coat on a 100% silk shirt with paisley patterns and flowers. Autumn/Winter 1986/1987 collection. © Photo: Hans Feurer.
Black on black? Or rather, gold on black. Black cardigan and roll-neck sweater in lambswool flocked in gold. Autumn/Winter 1986/1987 collection. © Photo: Hans Feurer.

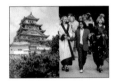

The castle of Himeji, which dominates the region in Hyogo where Kenzo grew up: memories that have always remained with him. © All rights reserved.
"Full Moon at Kyoto." Quilted kimono coats, in duchess satin, some of which are hand-painted. "Folk traditions from all over the world can go hand in hand." Autumn/Winter 1996/1997 collection.© Photo: Jean-Louis Coulombel.

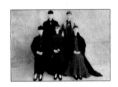

"The Chinese Women." A mixture of different collections based on the theme of "Liberty," for the exhibition of the same name. A typical example is the model seated left: shirt (Autumn/Winter 1975/1976), trousers (Autumn/Winter 1985/1986), jacket (Spring/Summer 1987). © Photo: Marianne Chemetov.

White on white. White light: extravagant flounces around the neck and hem of a cotton poplin blouse. Spring/Summer 1990 collection. © Photo: Hans Feurer.

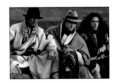

Interplay of scarves and ponchos over tweed and flannel trousers. Kenzo was the first to glorify color for men, in the face of the traditional subdued grey suit and tie. Autumn/Winter 1985/1986 ready-to-wear collection. © Photo: Peter Lindbergh.

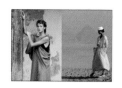

Mediterranean past and present, from Rome to the Pyramids. "Toga" dress of bourette silk: supple drapes, restrained colors, and simple lines. Spring/Summer 1983 collection (left). Striped cotton and small fellah cap, of Egyptian inspiration. Spring/Summer 1984 collection (right).© Photos: Sacha/Marie Claire Copyright.

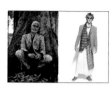

Urban mix. Cotton suit with vegetal print. Spring/Summer 1998 collection. © Photo: Jean-Baptiste Mondino.
Linen, cotton, and silk for this hybrid outfit. Jacket in linen mix over V-necked pullover and shirt, with cotton sarong over fitted trousers and long silk scarf. Spring/Summer 1998 collection. © All rights reserved.

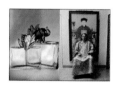

A time for perfumes. *Kenzo Jungle*, a spicy new-age, stimulating, joyful, and generous scent; in the *Éléphant* version for 1996 and *Tigre* for 1997. © Photo: Marc Dardanne.
China of old. Dressed in a traditional Chinese robe of yellow embroidered silk (the imperial color), Kenzo poses in front of the portrait of a court dignitary of the 18th century. © Photo: Jean-Marie Périer/Elle/Scoop.

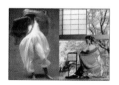

From one exoticism to another: twenty years separate these two photographs. India in filigree: silk dress, pearls slung over the shoulder and shawl spun with gold, like a sari. Spring/Summer 1978 collection (left). © Photo: Peter Lindbergh. Against the background of a Japanese garden (Kenzo's, in fact), a huge shawl in *dévoré* velvet and silk printed with peonies. Autumn/Winter 1998/1999 collection (right). © Photo: Jean-Marie Périer/Elle/Scoop.

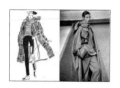

The start of a journey according to Kenzo. An illustration by Keiko Nagata which underlines Kenzo's taste for flexibility, with interchangeable garments. From the press pack for the Autumn/Winter 1991/1992 collection (left). © All rights reserved. Reversible caftan in blue mohair and yellow shantung silk, with roll-neck tunic in yellow mohair, over wide woollen-tweed trousers. Autumn/Winter 1998/1999 collection (right). © Photo: François Maillard, Alain Smilovici.

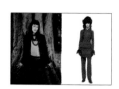

Spring/Summer 1998 collection. Jacket with Mao collar and patch pockets, openwork-knit trousers in a cotton mix. © Photo: Jean-Baptiste Mondino.
Journey through the Asian steppes. Short, fitted, collarless jacket and short wrap-around skirt with cigarette pants in brown wool mix. Autumn/Winter 1997/1998 collection. © All rights reserved.

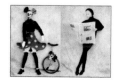

The master's joke. Kenzo disguised as Minnie Mouse for the "Liberty" exhibition. Blue skirt with large yellow spots over black leggings (1979); black pullover with huge red butterfly bow (Autumn/Winter 1989/1990 collection). © Photo: Marianne Chemetov.
"La Parisienne," another theme from the "Liberty" exhibition. Black roll-neck pullover, black leggings and a Basque beret. © Photo: Marianne Chemetov.

The publishers would like to thank the Kenzo fashion house, and particularly Ruth Obadia and Laurent Latko, as well as the press office, for their assistance in preparing this book.

Thanks are also due to all those who have participated in the work, in particular Marianne Chemetov and Julie Andrieu, as well as Gilles Bensimon, Denis Broussard, Jean-Louis Coulombel, Marc Dardanne, Hans Feurer, Peter Lindbergh, François Maillard, Jean-Baptiste Mondino, Jean-Bernard Naudin, Jean-Marie Périer, Sacha, Alain Smilovici, Pascal Therme and Oliviero Toscani.

Finally, this work would not have been possible without the kind assistance of Madame Masui ("Liberty" exhibition), Claudine Legros (Elle/Scoop), Gwenaëlle Dautricourt and Nathalie Dewulf (Marie Claire Copyright) Sandrine Bizzard (Michele Filomeno), Véronique (Catherine Mathis & Fils), Emmanuelle (Yannick Morisot) and Carole Dardanne (Dark Prod).